IMAGES
of America

LOS ANGELES
RIVER

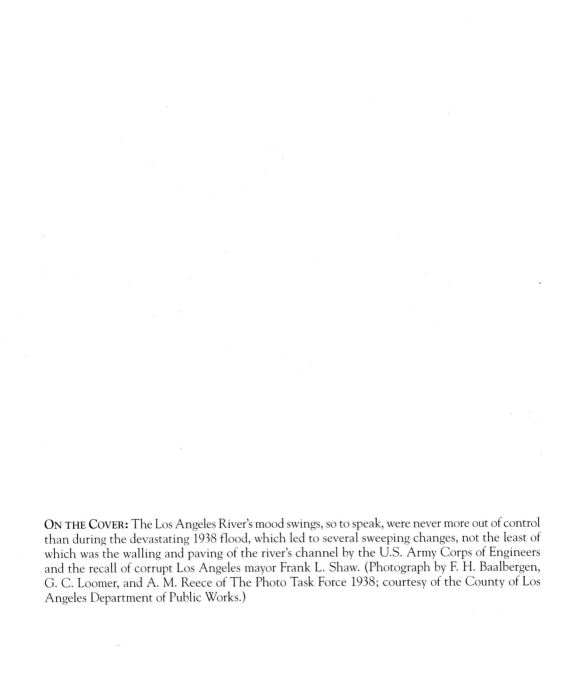

ON THE COVER: The Los Angeles River's mood swings, so to speak, were never more out of control than during the devastating 1938 flood, which led to several sweeping changes, not the least of which was the walling and paving of the river's channel by the U.S. Army Corps of Engineers and the recall of corrupt Los Angeles mayor Frank L. Shaw. (Photograph by F. H. Baalbergen, G. C. Loomer, and A. M. Reece of The Photo Task Force 1938; courtesy of the County of Los Angeles Department of Public Works.)

IMAGES
of America

LOS ANGELES
RIVER

Ted Elrick and the
Friends of the Los Angeles River

ARCADIA
PUBLISHING

Published by Arcadia Publishing
Charleston SC, Chicago IL, Portsmouth NH, San Francisco CA

Printed in the United States of America

Library of Congress Catalog Card Number: 2006935603

For all general information contact Arcadia Publishing at:
Telephone 843-853-2070
Fax 843-853-0044
E-mail sales@arcadiapublishing.com
For customer service and orders:
Toll-Free 1-888-313-2665

Visit us on the Internet at www.arcadiapublishing.com

For Lori, James, and Caitlin, as well as Jack, Diane, June, Bill, Doris, Don, Jean, and the memory of Betty

CONTENTS

ACKNOWLEDGMENTS

This book would not have been possible without the generous support of numerous individuals and organizations that provided not only photographs, but also good wishes. I would like to thank Christian Garcia and Heather Speight from the County of Los Angeles Department of Public Works; Carolyn Cole of the Los Angeles Public Library; Genie Guerard of the Department of Special Collections, Charles E. Young Research Library, UCLA; Jim Appleton, James White, Grace Quon, and Morris Brown of CalTrans; director Randal Kleiser; director John Badham; Margarita Diaz and Doug Gauthier, Sony Pictures; John Solberg, Dina Oxenberg, and Richard Kosters, FX; Brian Palagallo, Paramount Pictures; Julie Heath, Jacklyn Pomales, Yvonne Smith, and Shelley Billik, Warner Brothers Pictures; Michele Dubal, Justine Keeran, and Pauline Houston, National Notary Association; Sarah E. Starr; Jay and Vicki Ann Sheveck; Steve Rubin; Los Angeles River expert Joe Linton; Friends of the Los Angeles River executive director Shelly Backlar; the Ingle Group, Jeff and Jody Ingle; Jim Walker, archivist of the Metropolitan Transit Authority; and for the patience of publisher Christine Talbot and editor Jerry Roberts from Arcadia Publishing.

INTRODUCTION

"You call that a river?"

It is a question many people wonder when they first see the blue sign announcing the Los Angeles River featuring the white image of a great blue heron. The signs are on every road crossing of the concrete-imprisoned trickle of water that looks more like a giant gutter than a river.

That was exactly what I thought the first time I laid eyes on it. Having come from Pittsburgh where the mighty three rivers—the Monongahela, Allegheny, and Ohio—were wide, deep, seemingly eternal, still uncontrollable when winter thaws, and constantly being traveled by coal barges and recreational boats, I could not imagine how anyone could possibly call this trickle a river.

This barely visible runoff inside broad expanses of graffiti-covered concrete was on the map as the Los Angeles River. Who were they kidding? Was this yet another example of Hollywood's misconceptions of reality?

Historically, people have always underestimated or not taken seriously the fact that the Los Angeles River was, and still is, a river. At times, it could be just as wild and dangerous a river as any in America. It just had the misfortune of—or perhaps nature's cunning to—offer an often-meek appearance. It could appear to be a pleasant, meandering stream subject to dry spells, giving people a false sense of safety. While the entire Pueblo de Los Angeles depended upon it for water, transplants were lulled into forgetting that you do not build or settle in the path of something that has a tendency to flood every once in a while.

But so many new Angelinos were lured to the area that the city literally exploded population-wise. It grew so quickly during the early 20th century that local government could not keep up with the influx, let alone consider addressing such things as building zoning restrictions. Like that other, ever present, Southern California danger, earthquakes, a catastrophic flood was just around the corner. The final concrete controlling of the river occurred after the flood that resulted from the massive rainstorm of March 1938. It was then that the local government asked the U.S. Army Corps of Engineers to improve the river to prevent future flooding.

The Los Angeles River is approximately 51 miles long from its beginning in Canoga Park, where Bell Creek and Arroyo Calabasas converge, to its mouth into San Pedro Bay at the Port of Long Beach. For the majority of its length, as well as that of its tributaries, it is encased in concrete. However, there are three areas where the river has retained an earthen, "soft" bottom—in the Sepulveda Basin, the Glendale Narrows, and the estuary in Long Beach.

It is in these areas one can get a sense of what the river might have been like when the Spanish came upon a group of Native Americans that they called the Gabrielino. These Native Americans may not have had a name for themselves, as Hugo Reid, a Scottish trader, attested. He came to Los Angeles in 1832 and married a Native American. Others vowed that the group called themselves the Tongva. They were considered to have been perhaps the most culturally advanced and prosperous of Southwest Native Americans, having developed up to that time an extensive trade network. Some believe they were the first Native Americans to use movable stone

mortars for grinding acorns and other plants. The Tongva also depended on the river for water and its attraction to animals they could hunt.

Though the Spanish first came to California in 1542, landing at San Diego Bay, it wasn't until the mid-18th century that the Spanish, spurred on by exaggerated tales of Russian activity in the Northern Pacific, began making overland expeditions into California. One such expedition was under the command of Gaspar de Portola, governor of Baja California. He was resting on August 1, 1769, to honor the jubilee of Nuestra Senora de los Angeles de la Porciuncula (Our Lady of the Angels of Porciuncula, named for a small church in Assisi, Italy), when a group of hunters returned and said that they had seen a very full flowing and wide river.

According to the diaries of Fr. Juan Crespi, the expedition came upon a green, lush valley with a river estimated to be 7 yards wide and filled with water that was pure and fresh. Though the feast of Our Lady of the Angels of Porciuncula had begun the previous day at noon, it did not end until that day at midnight, and so the Spanish named the valley in honor of that plenary indulgence of the Catholic Church.

The Spanish had noticed the Los Angeles River.

One

THE RIVER

Like many civilizations, the Tongva depended on the river. The same held true for early Angelinos. The river provided water for drinking and agriculture. Farmland, orchards, and vineyards sprouted up all around the tiny pueblo of Los Angeles. Water was brought through an ingenious system of *zanjas*, or ditches. The *Zanja Madre* (Mother Ditch) was the largest and the most central ditch and was completed in October 1781. Traces of the *Zanja Madre* were uncovered by a pair of amateur archeologists—Craig Howell and Melody Carver—in February 2000 near Chinatown (see photograph in chapter five). The *Zanja Madre* ran from the Los Angeles River south toward the town's main plaza on present-day Olvera Street. From there it split into two ditches—one for farmlands; the other ran behind the houses to provide water for domestic needs. In 1858, a giant waterwheel was constructed near Chinatown, which raised the water up to a flume that carried it to a reservoir near Olvera Street. This wheel was destroyed by a flood.

As the city grew, so did its demands for water. By 1888, the city maintained a *zanja* system, numbering 15 *zanjas* and 9 branches, which carried water through more than 52 miles inside the city's boundaries.

The early 20th century saw a great population explosion in Los Angeles. The number of people nearly doubled between the years 1902 and 1906, from 128,000 to 240,000. This growth created an equally explosive demand for the river's water. The consumption was so great that the water table dropped, and private wells that were once deep enough to provide ample water now were nearly dry. Conversely, the river sporadically made more demands on the population.

This map depicts the course of the Los Angeles River and its major tributaries from Canoga Park, California, to its mouth in Long Beach, California. The map was drawn by artist and Los Angeles River expert Joe Linton, author of the walking, cycling, and fact-filled guide *Down by the Los Angeles River*. The significant tributaries include Compton Creek, Rio Hondo, Arroyo Seco, and the Tujunga Wash. (Courtesy of Joe Linton.)

This placid scene of the Los Angeles River was taken some time in the 1800s in what is now known as Griffith Park. It was named for Col. Griffith J. Griffith, who donated more than 3,000 acres to create the park and a fortune to build the Griffith Park Observatory on the parkland. (Courtesy of the Los Angeles Public Library/Security Pacific National Bank Collection.)

This waterwheel was built in the late 1850s to raise water from the L.A. River into the *Zanja Madre*, or "Mother Ditch," of early L.A. to provide water for irrigation. The wheel was destroyed in a flood. (Courtesy of the Los Angeles Public Library/Security Pacific National Bank Collection.)

Taken in 1873, this view looks toward Brooklyn Heights, now called Boyle Heights, and East Los Angeles from the hill north of Bishop Street at North Broadway. The Old Downey Avenue Bridge across the Los Angeles River is visible. (Courtesy of the Los Angeles Public Library/Security Pacific National Bank Collection.)

This photograph shows a *zanja* (canal) through Central Park, later renamed Pershing Square, in the heart of downtown before 1882. This was Zanja No. 6 and was built by O. W. Childs, who was the lower of two bidders for the project. In payment for the construction of the *zanja*, Childs received land from Sixth Street to Pico Boulevard and Main Street to Figueroa Street, a vast section of real estate worth a large fortune in today's dollars. (Courtesy of the Los Angeles Public Library/Security Pacific Collection.)

This is a photograph of the devastation wrought by one of the earliest photographed Los Angeles River floods. In it, a 19th-century Los Angeles streetcar rests precariously, nose first, in a ditch at an unknown location following flooding in 1884. (Courtesy of the County of Los Angeles Department of Public Works.)

This is an early aerial view of Los Angeles taken on June 27, 1887, from the "Examiner" balloon. It depicts extensive farmland near the river south of Second Street and east of Main Street. (Courtesy of the Los Angeles Public Library/Security Pacific National Bank Collection.)

Because of its climate and long growing season, California has always depended on agriculture. Pictured here in the 1890s is a group of grape pickers in the San Gabriel Valley. (Courtesy of the Los Angeles Public Library/Security Pacific National Bank Collection.)

Along the north side of what is now Griffith Park, an irrigation canal takes water from the L.A. River. The photograph is dated 1895. (Courtesy of the Los Angeles Public Library/Security Pacific National Bank Collection.)

Taken in 1900, this photograph shows a *zanja*, the original water supply channel for the southwest part of the city, on Figueroa Street near Washington Boulevard. The channels, originally built in 1868, were rebuilt in 1885 with concrete. (Courtesy of the Los Angeles Public Library/Security Pacific National Bank Collection.)

This view of the Los Angeles River and the farming areas north from Elysian Park was taken in 1900 looking toward Cypress Park and Glassell Park. (Courtesy of the Los Angeles Public Library/Security Pacific National Bank Collection.)

This idyllic scene depicted on a turn-of-the-20th-century postcard from Sohmer Brothers Los Angeles and published by Western Publishing and Novelty Company, Los Angeles, shows the Elysian Valley with farmland on one side and the railroad on the other. Compare the position of the train yard in this postcard with that in the photograph from the 1938 flood found on pages 40 and 41. (Courtesy of the Roger Creighton Collection.)

John W. Johnson owned the Pigeon Farm next to the Los Angeles River near Elysian Park. Begun in 1892, the farm, seen on this vintage postcard, provided squab for local restaurants and hotels. Partially damaged by floodwaters in 1912, it was completely destroyed in 1914. (Courtesy of Jim Walker.)

This house slipped into the Los Angeles River during flooding in 1914. The flood covered 12,000 acres, and thus began a 20-year-long project to dam small tributaries in the upper mountain canyons. (Courtesy of the Los Angeles Public Library/Security Pacific National Bank Collection.)

Even the tributaries could bring devastation during flood season. Pictured here is the collapsed Arroyo Seco Bridge in 1924; the majority of the bridge is lying in the creek. The Arroyo Seco is the winding streambed between downtown Los Angeles and Pasadena. (Courtesy of the Department of Special Collections, Charles E. Young Research Library, UCLA.)

During quieter times, the Los Angeles River and its tributaries offered welcome relief from the Southern California heat. Seen here is a group of boys enjoying a swim in the Arroyo Seco Creek. (Courtesy of the Department of Special Collections, Charles E. Young Research Library, UCLA.)

The Los Angeles River flooding of 1914 caused the downing of the Seventh Street Bridge in downtown Los Angeles. (Courtesy of the Los Angeles Public Library/Security Pacific National Bank Collection.)

An aerial view depicts the downtown Los Angeles business district with the North Broadway Bridge over the L.A. River. (Courtesy of the Los Angeles Public Library/Security Pacific National Bank Collection.)

Compton was hit hard by the Los Angeles River in the flood of 1926, as pictured here. Compton Creek, which drains today's communities of Watts and Willowbrook, joins the river at the northernmost point where the cities of Carson and Long Beach meet. (Courtesy of the Los Angeles Public Library/Security Pacific National Bank Collection.)

This photograph, taken on April 7, 1926, shows the floodwaters racing down the Eaton Wash just north of the Blanche Street Bridge. Eaton Canyon begins up on Eaton Saddle near San Gabriel Peak and Mount Markham in the San Gabriel Mountains and flows into the Rio Hondo. (Courtesy of the County of Los Angeles Department of Public Works.)

Taken at 4:15 p.m., one hour after the raging Rio Hondo's destruction of the Foothill Boulevard Bridge on April 7, 1926, this view looks north. (Courtesy of the County of Los Angeles Department of Public Works.)

The following day, floodwaters were still raging, as depicted in this picture taken from the bridge east of Tweedy schoolhouse looking north into Maywood from the Huntington Park/city of Bell areas on April 8, 1926, at 10:00 a.m. (Courtesy of the County of Los Angeles Department of Public Works.)

Los Angeles County flood control engineer J. W. Reagan, left, and county supervisor Henry W. Wright are seen standing on a bridge looking down at the Pacoima Dam site in 1926. Pacoima Wash rises in the San Gabriel Mountains and flows into Tujunga Wash, a confluence of the Los Angeles River. (Courtesy of the Department of Special Collections, Charles E. Young Research Library, UCLA.)

The Los Angeles River flooded yet again in 1927, washing this unidentified bridge away. (Courtesy of the Department of Special Collections, Charles E. Young Research Library, UCLA.)

This view looks north from Los Feliz Boulevard to the Los Angeles River on February 16, 1927. The lands to the left, or west, comprised Griffith Park; those to the right formed a strip of City of Los Angeles land along the east bank of the river contiguous with Glendale. (Courtesy of the County of Los Angeles Department of Public Works.)

Underneath the Universal City Bridge on February 16, 1927, a photographer captures the raging waters of the L.A. River. (Courtesy of the County of Los Angeles Department of Public Works.)

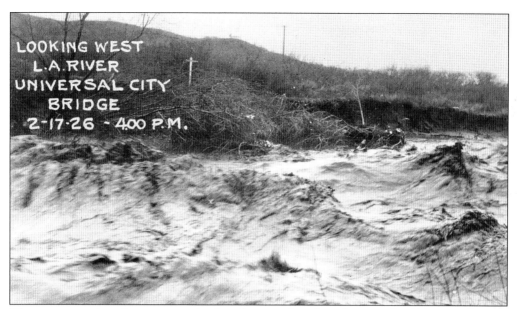

The waters continued to roar past in this photograph, taken the next day, February 17, 1927, looking west from the Universal City Bridge. (Courtesy of the County of Los Angeles Department of Public Works.)

Completed in 1926, the St. Francis Dam in San Francisquito Canyon near Saugus failed in 1928. It was part of the Owens Valley Aqueduct System. News of this tragedy rippled throughout Los Angeles, causing concern to rise among Angelinos whose memories of past Los Angeles River floods were still keen. Dam strength, erosion, and value were called into question after the St. Francis Dam disaster. This post-failure photograph shows several men looking very small as they stand in the area below the failed dam. One large chunk of dam remains standing while another lies on the ground below it. (Courtesy of the Los Angeles Public Library/Security Pacific National Bank Collection.)

Here is what Main Street in Burbank, California, looked like in this *Los Angeles Times* photograph from November 14, 1928. A heavy rainstorm caused debris to wash across large areas. (Courtesy of the Department of Special Collections, Charles E. Young Research Library, UCLA.)

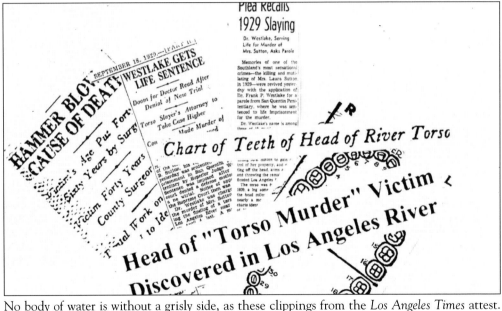

No body of water is without a grisly side, as these clippings from the *Los Angeles Times* attest. Among the true tales of the L.A. River is the April 4, 1929, discovery of a headless, limbless body in the river. The newspapers dubbed it the "Torso Murder Case," and speculation was rampant for a month. Those not hearing from loved ones suspected the worst. In March, a group of boys stumbled upon the woman's head in the quicksand near Florence Avenue, and they claimed the $1,000 reward for the head offered by the *Los Angeles Herald Express*. The cause of death was a blow to the back of the head with a hammer. Laura B. Sutton was identified from dental records. Justice moved swiftly, and Dr. Frank P. Westlake was convicted of the murder on Saturday, September 7, 1929. The prosecution successfully convinced the jury that he sought to gain control of the victim's estate. On September 10, he was sentenced to life imprisonment at San Quentin.

Two

THE GREAT FLOOD

The rains began on February 27, 1938, and by March 3, some areas of the San Gabriel Mountains had received more than 32 inches of rain, nearly as much as they receive in a full year. It proved too much for the soaked slopes to absorb.

As bad as previous floods had been, nothing compared to the flood of March 1938. The March 4, 1938, issue of the *Los Angeles Times* reported that 1,500 homes were uninhabitable and 3,700 refugees flocked to theaters, schools, and camps. Six hundred and eighty-eight people were confirmed dead and another 127 were missing. After taking a plane trip to survey the damage, *Times* reporter James Bassett Jr. wrote, "From 3,000 feet, a scene unfolds that groundlings can never grasp. Disaster, gutted farmlands, ruined roads, shattered communications, wrecked railroad lines—all leap into sharp etched reality from that altitude."

Like today, news from Los Angeles also featured how the flood affected Hollywood. While the front page listed the names of the dead who had been identified, page four of the March 5, 1938, issue of the *Times* ran a photograph and story about the river's damage to the estate of actor Ralph Bellamy. The March 14, 1938, issue of *Time* magazine reported that "all studios except Twentieth Century-Fox stopped work to fight the water. Victor McLaglen suffered a $20,000 loss when his sports stadium was virtually swept away by floodwaters. In her basement, Lucille Ball found her wire-haired terrier swimming in four feet of water. Marooned at his Chatsworth Ranch, Robert Taylor had to ride a horse two miles to reach a highway. Shirley Temple and her mother spent the night at her studio."

The flood washed away 20 bridges, and property damage exceeded $78 million in 1938, nearly a billion in today's dollars. Though Los Angeles had begun taking steps to address flood control, it would take a disaster of this magnitude before it reached out to work with the federal government toward a comprehensive plan.

This steam shovel fills railway carts with dirt from the not-yet-empty Chatsworth Reservoir in 1930. Today the reservoir is dry. Owned by the Los Angeles County Department of Power and Water, the reservoir remains undeveloped as a habitat for wildlife. (Courtesy of the Department of Special Collections, Charles E. Young Research Library, UCLA.)

This is the watery view seen from Reseda Boulevard in the San Fernando Valley on February 9, 1932, at 3:55 in the afternoon. This image was created by the Department of Public Works by joining two photographs together to emphasize the size of the flooding. (Courtesy of the County of Los Angeles Department of Public Works.)

From a railroad bridge on West Whittier Boulevard, the Rio Hondo is seen clearly ready to overflow its channel. The Rio Hondo is a main tributary of the Los Angeles River, rising in the San Gabriel Mountains to the northeast of the city of Los Angeles. (Courtesy of the County of Los Angeles Department of Public Works.)

This is a different angle showing the spread of the water on the Rio Hondo in lands that eventually were incorporated as the City of Pico Rivera. (Courtesy of the County of Los Angeles Department of Public Works.)

This 1933 shot shows Vineland Avenue being washed out by the North Hollywood flood. The picture was taken from Ventura Boulevard looking north. (Courtesy of the Los Angeles Public Library/Security Pacific National Bank Collection.)

The home of Carl F. Gee and his family was located at 3113 Mayfield Avenue in Montrose until floodwaters carried it more than a block away from its foundation. La Crescenta Creek flows south out of the San Gabriel Mountains and Angeles National Forest through La Crescenta and into the Verdugo Wash several blocks from where, today, Mayfield Avenue parallels the Foothill Freeway. The Verdugo Wash arcs in a southwesterly direction across Glendale and enters the L.A. River where the big stream bends south around Griffith Park. (Courtesy of the Los Angeles Public Library/*Herald Examiner* Collection.)

With ever-present flooding, Angelinos tried to keep their sense of humor, as seen in this picture that appeared in the old *Los Angeles Daily News* depicting a couple wearing waders to cook at a stove in their flooded kitchen. The year is 1937, and this flooding was at Long Beach near the river's estuary. (Courtesy of the Department of Special Collections, Charles E. Young Research Library, UCLA.)

This aerial view of the Los Angeles River overflowing its banks drastically demonstrates the enormity of the 1938 flood. This flood not only caused citizens to forcefully demand that flood control be a major priority of politicos at all levels, but precipitated the recall of Los Angeles mayor Frank L. Shaw, who was also coming under fire for corruption in the police department. (Photograph by F. H. Baalbergen, G. C. Loomer, and A. M. Reece of The Photo Task Force 1938; courtesy of the County of Los Angeles Department of Public Works.)

This aerial view of the Lankershim Bridge in Universal City, after it was destroyed by floodwaters, shows the number of curious people gathered at the ends of the bridge to watch the waters rage past the now-destroyed structure. (Courtesy of the Los Angeles Public Library.)

Looking east downstream from the Dark Canyon Bridge, this view shows the L.A. River's north bank and First National Studio. As a production entity, First National had been taken over by Warner Brothers in the 1920s. (Photograph by F. H. Baalbergen, G. C. Loomer, and A. M. Reece of The Photo Task Force 1938; courtesy of the County of Los Angeles Department of Public Works.)

Showing the washout of the north levee behind Warner Brothers Studio, this photograph was taken on March 6, 1938. (Photograph by F. H. Baalbergen, G. C. Loomer, and A. M. Reece of The Photo Task Force 1938; courtesy of the County of Los Angeles Department of Public Works.)

Looking south from Victory Boulevard across a sea of debris, this is how Burbank looked in the spring of 1938. It is unknown if the "For Sale" sign was up before or after the flood. (Photograph by F. H. Baalbergen, G. C. Loomer, and A. M. Reece of The Photo Task Force 1938; courtesy of the County of Los Angeles Department of Public Works.)

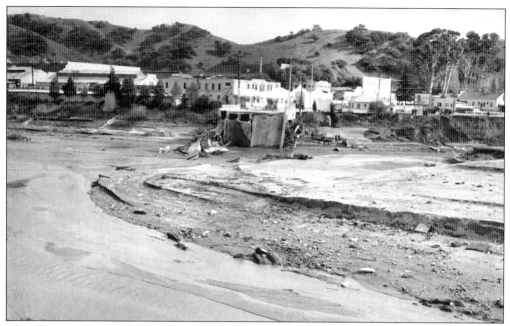

This photograph was taken looking south from the north bank of the Los Angeles River above Lankershim Boulevard. (Photograph by F. H. Baalbergen, G. C. Loomer, and A. M. Reece of The Photo Task Force 1938; courtesy of the County of Los Angeles Department of Public Works.)

This is a different angle of the area seen in the previous photograph, looking southeast from the north bank of the Los Angeles River above Lankershim Boulevard. (Photograph by F. H. Baalbergen, G. C. Loomer, and A. M. Reece of The Photo Task Force 1938; courtesy of the County of Los Angeles Department of Public Works.)

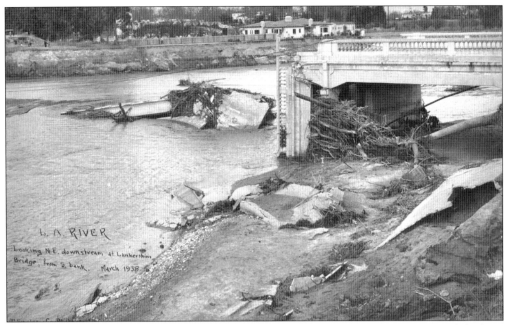

The downed Lankershim Boulevard Bridge in Universal City is visible in this photograph looking northeast from the south bank of the Los Angeles River. (Photograph by F. H. Baalbergen, G. C. Loomer, and A. M. Reece of The Photo Task Force 1938; courtesy of the County of Los Angeles Department of Public Works.)

From the end of the downed Lankershim Boulevard bridge, looking north on the boulevard, one can see the east branch of the Tujunga Wash in the background. (Photograph by F. H. Baalbergen, G. C. Loomer, and A. M. Reece of The Photo Task Force 1938; courtesy of the County of Los Angeles Department of Public Works.)

On March 5, 1938, residents assess water and mud damage at 4227 Agnes Avenue in Studio City, one block east of Laurel Canyon Boulevard. Today CBS Radford Studios is in the area. (Photograph by F. H. Baalbergen, G. C. Loomer, and A. M. Reece of The Photo Task Force 1938; courtesy of the County of Los Angeles Department of Public Works.)

This photograph was taken on March 4, 1938, looking northeast at the house occupying 1325 Randall Street where the Los Angeles River's floodwaters reached 1.3 feet above the doorsill. (Photograph by F. H. Baalbergen, G. C. Loomer, and A. M. Reece of The Photo Task Force 1938; courtesy of the County of Los Angeles Department of Public Works.)

Just east of Tujunga Avenue in Studio City, this view looks upstream from the south bank of the Los Angeles River. (Photograph by F. H. Baalbergen, G. C. Loomer, and A. M. Reece of The Photo Task Force 1938; courtesy of the County of Los Angeles Department of Public Works.)

Angelino motorists attempt to get back to business as usual, steering on what little remains of this section of road, avoiding the washout and riverbank. (Photograph by F. H. Baalbergen, G. C. Loomer, and A. M. Reece of The Photo Task Force 1938; courtesy of the County of Los Angeles Department of Public Works.)

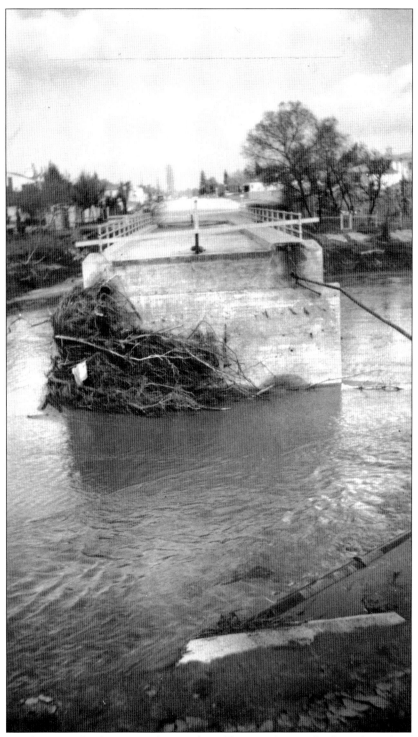

Looking north across the then recently wiped out Tujunga Avenue bridge, a big pile of debris is seen in the flood's wake. (Photograph by F. H. Baalbergen, G. C. Loomer, and A. M. Reece of The Photo Task Force 1938; courtesy of the County of Los Angeles Department of Public Works.)

Further rail damage is seen here, as well as buildings that came quite close to having the earth wash from underneath them. This shot was taken in the lower portions of Elysian Park, the future hilltop home of Dodger Stadium. (Photograph by F. H. Baalbergen, G. C. Loomer, and

A. M. Reece of The Photo Task Force 1938; courtesy of the County of Los Angeles Department of Public Works.)

Railroad service was severely impacted by the 1938 flood, as demonstrated in this photograph near the Fletcher Drive Bridge in today's Silver Lake/Atwater Village area. (Photograph by F. H. Baalbergen, G. C. Loomer, and A. M. Reece of The Photo Task Force 1938; courtesy of the County of Los Angeles Department of Public Works.)

On March 7, 1938, this picture, taken from Valleyheart Drive in Studio City looking toward the Laurel Canyon Boulevard Bridge, depicts the amount of earth that fell away from under the bridge. (Photograph by F. H. Baalbergen, G. C. Loomer, and A. M. Reece of The Photo Task Force 1938; courtesy of the County of Los Angeles Department of Public Works.)

This picture was taken looking east and downstream near the intersection of Valleyheart Drive and St. Clair Avenue. (Photograph by F. H. Baalbergen, G. C. Loomer, and A. M. Reece of The Photo Task Force 1938; courtesy of the County of Los Angeles Department of Public Works.)

Pre-1938 attempts to reign in the river proved no match for this storm's floodwaters, as graphically depicted in this photograph taken from Valleyheart Drive looking downstream. (Photograph by F. H. Baalbergen, G. C. Loomer, and A. M. Reece of The Photo Task Force 1938; courtesy of the County of Los Angeles Department of Public Works.)

Seen here is even further dramatic evidence depicting how ineffectual pre-1938 flood measures were to combat the waters from this storm. The photograph was taken slightly further downstream from the previous photograph on March 25, 1938, from a location between Laurel Grove and St. Clair Avenue. (Photograph by F. H. Baalbergen, G. C. Loomer, and A. M. Reece of The Photo Task Force 1938; courtesy of the County of Los Angeles Department of Public Works.)

This picture, clearly showing major damage to the concrete meant to hold back the Los Angeles River's ravages, was taken looking southwest and upstream from the north bank at Valleyheart Drive and Vantage Avenue. (Photograph by F. H. Baalbergen, G. C. Loomer, and A. M. Reece of The Photo Task Force 1938; courtesy of the County of Los Angeles Department of Public Works.)

Taken from Hyperion Avenue, this photograph shows a general view of the damages inflicted by the Los Angeles River on Victor McLaglen Stadium. (Photograph by F. H. Baalbergen, G. C. Loomer, and A. M. Reece of The Photo Task Force 1938; courtesy of the County of Los Angeles Department of Public Works.)

The river's impact can clearly be seen in this view of the washout under the grandstand of Victor McLaglen Stadium. (Photograph by F. H. Baalbergen, G. C. Loomer, and A. M. Reece of The Photo Task Force 1938; courtesy of the County of Los Angeles Department of Public Works.)

A gallant soul inspects the damage to the grandstand of Victor McLaglen Stadium. McLaglen, a former prizefighter, won the Academy Award for Best Actor for his performance as Gypo Nolan in John Ford's *The Informer* (1935), and also acted in support of John Wayne in Ford's films *Fort Apache* (1948), *She Wore a Yellow Ribbon* (1949), and *The Quiet Man* (1952). (Photograph by F. H. Baalbergen, G. C. Loomer, and A. M. Reece of The Photo Task Force 1938; courtesy of the County of Los Angeles Department of Public Works.)

Here is a closer view of the washout under the grandstand of Victor McLaglen Stadium. The multipurpose stadium had been used for such things as horse shows, car shows, road races, and ball games of all kinds. (Photograph by F. H. Baalbergen, G. C. Loomer, and A. M. Reece of The Photo Task Force 1938; courtesy of the County of Los Angeles Department of Public Works.)

This photograph was taken from Riverside and the Dayton Bridge in the Elysian Valley looking toward Taylor Yard. (Photograph by F. H. Baalbergen, G. C. Loomer, and A. M. Reece of The Photo Task Force 1938; courtesy of the County of Los Angeles Department of Public Works.)

Looking like giant billboards, concrete slabs jut out from the Verdugo Wash, having had the dirt they were holding back ripped from behind them from the force of the flood. (Photograph by F. H. Baalbergen, G. C. Loomer, and A. M. Reece of The Photo Task Force 1938; courtesy of the County of Los Angeles Department of Public Works.)

To lighten up the misery caused by the greatest rainstorm and heaviest rainfall in Southern California history, *Herald-Express* photographer Coy Watson Jr., left, and reporter Fred Eldridge attempt a boat expedition from Hyperion Avenue to Long Beach. This storm was the inducement to begin building the concrete channel for the Los Angeles River. Watson was one of the renowned Watson family press photographers. (Courtesy of the Los Angeles Public Library/ *Herald Examiner* Collection.)

While sailing on the muddy Los Angeles River, the boat of the two adventurers overturned on a shoal. After righting their boat, "Foghorn" Eldridge is seen up to his chest in mud, blowing the distress horn. "Wharf Rat" Watson waves the flag he had intended to plant on the shores of Long Beach if and when they sailed the length of the river. (Courtesy of the Los Angeles Public Library/*Herald Examiner* Collection.)

A crowd was on hand to greet the two adventurers when they brought their boat to shore from the muddy Los Angeles River. Fred Eldridge and Coy Watson Jr. were congratulated for maneuvering through the dangerous rapids on the river. They sailed between a tractor and a ditch digger lying in the river. Aside from illustrating the flood with some humor, the duo also aped the intrepid and robust style of a brand of reporter/adventurer of the day, the type who braved nature's consequences and lived to tell the tale. (Courtesy of the Los Angeles Public Library/*Herald Examiner* Collection.)

Three

TAMING THE RIVER

While the 1938 flood had been disastrous, it could have been far worse. The flood had demonstrated the effectiveness of measures taken along certain stretches of the river. There had been very little damage south of Arroyo Seco because the river had been confined from Los Angeles to the Pacific. The most serious damage had occurred in areas where flood-control measures had yet to be enacted or where they were clearly ineffectual. For instance, a channel that had been dug for the river proved far too small to accommodate large volumes of water, and this caused the river to spread over large areas west of Encino. Van Nuys had been isolated for several days because all bridges had been either flooded or destroyed.

On April 7, 1947, the U.S. Army Corps of Engineers hosted "Army Day" to show the public the six dams and flood-control basins whose construction it had supervised. The construction of these dams had started after the 1938 flood and had continued throughout the course of World War II. The public flocked to hear from experts how these dams would tame the Los Angeles, San Gabriel, and Santa Ana Rivers, and prevent the flooding they had experienced.

Longest of the dams completed was the Sepulveda Dam, finished in 1941. It stretched 15,300 feet and cost $6.5 million. Hansen Dam, between San Fernando and Sunland on the Tujunga Wash, completed a mere 43 months after the 1938 flood, is 97 feet high (40 feet higher than Sepulveda) and stretches 9,050 feet.

For the most part, the dams and the construction of the concrete channels that would continue have prevented another major catastrophe.

Pictured above is an artist's sketch that graphically portrays the system of dams, underground storage basins, etc., that were set up by the Los Angeles County engineers to prevent floods and to conserve hitherto wasted rain water for domestic purposes. (Courtesy of the Los Angeles Public Library/*Herald Examiner* Collection)

This photograph shows the U.S. Army Corps of Engineers timing the flow of the Los Angeles River under the Dayton Avenue Bridge. (Courtesy of the Los Angeles Public Library/*Herald Examiner* Collection.)

After the flood, a flurry of construction efforts began trying to tame the sometimes-raging Los Angeles River. Pictured above on April 28, 1938, are workers building framing for concrete and digging during the reconstruction of the Los Angeles River. (Courtesy of the Department of Special Collections, Charles E. Young Research Library, UCLA.)

Construction work is underway on the east side of the Los Angeles River channel between Twenty-third Street and Downey Road in Vernon on December 3, 1938. Today Vernon is an industrial city with a 2000 U.S. Census population of 91 and a daily work force of about 54,000. (Courtesy of the Department of Special Collections, Charles E. Young Research Library, UCLA.)

A power shovel and bulldozer are pictured submerged in water that rushed down the Arroyo Seco into the Los Angeles River just east of Figueroa Street. The storm came so quickly that there wasn't time to get the machinery out of the streambed. Ironically, the equipment was being used for flood-control work. (Courtesy of the Los Angeles Public Library/*Herald Examiner* Collection.)

Martha Kaime, a chemist, is seen filtering water from the Los Angeles River; she drank the water after it was filtered. In the background, a canopy is set over a truck carrying equipment to test the water in the river. A long hose can be seen running from the water to the equipment on the truck. (Courtesy of the Los Angeles Public Library/*Herald Examiner* Collection.)

Edward Koehn, left, chief of flood-control design for the U.S. Army Corps of Engineers, Los Angeles District, explains the Los Angeles River's water flows to colleagues via a plywood model demonstration of the proposed channel improvements, perhaps where the Arroyo Seco channel joins the main stream north of downtown Los Angeles. (Courtesy of the Los Angeles Public Library/*Herald Examiner* Collection.)

On October 23, 1944, all charges against those convicted of the "Sleepy Lagoon Murder" were overturned at the appellate level. These celebrations, left and below, resulted. On August 2, 1942, 21-year-old Jose Diaz was killed during a picnic at Sleepy Lagoon Reservoir next to the Los Angeles River on the Williams Ranch in Montebello. The area is now in the City of Bell, south of Maywood. Police rounded up 600 Mexican Americans, and the Los Angeles district attorney prosecuted 22, receiving 12 convictions. Three were given life sentences. The appellate court found evidence presented at their trial "woefully lacking" and criticized the lower court's official conduct during the 13-week trial. The "Sleepy Lagoon" convictions led to heightened tensions, and some feel they also led to the "Zoot Suit Riots." (Both courtesy of the Department of Special Collections, Charles E. Young Research Library, UCLA.)

On May 31, 1943, twelve sailors clashed violently with Mexican American youths in downtown Los Angeles and one seaman was badly wounded. On June 3, four-dozen sailors with concealed weapons sought revenge on anyone wearing a Zoot suit, giving birth to the infamous "Zoot Suit Riots." The *Los Angeles Times* criticized First Lady Eleanor Roosevelt, who called the incidents race riots. During the riots, 1,000 officers and deputies rounded up anyone in East Los Angeles of Latino decent. One of the few newspapers that denounced the treatment of the Mexican Americans was the Watts-based *California Eagle*. This edition is from June 17, 1943. (Courtesy of the Southern California library for Social Study and Research.)

Construction of the channel walls in the Los Angeles River by the U.S. Army Corps of Engineers is pictured here at Laurel Canyon in Studio City near today's location of CBS Radford Studios. (Courtesy of the Los Angeles Public Library/*Hollywood Citizen News*/*Valley Times* Collection.)

The original caption for this newspaper photograph reads, "The Los Angeles river hasn't had very much water, as you can see in the photograph; it has been dry for many years. So, officials were thinking about converting the waterway into a high-speed freeway. They are seen on an inspection tour at the river." Victims of the 1938 flood may or may not have found it as sarcastic a comment on the effectiveness of officials as the paper's editors. (Courtesy of the Los Angeles Public Library/*Herald Examiner* Collection.)

The refurbished Los Angeles River is shown off in its new cement and concrete in this aerial view on January 1, 1949. Radford Street in Studio City crosses in the center, and the unimproved section extends to the upper left. (Courtesy of the Los Angeles Public Library/*Hollywood Citizen News*/*Valley Times* Collection.)

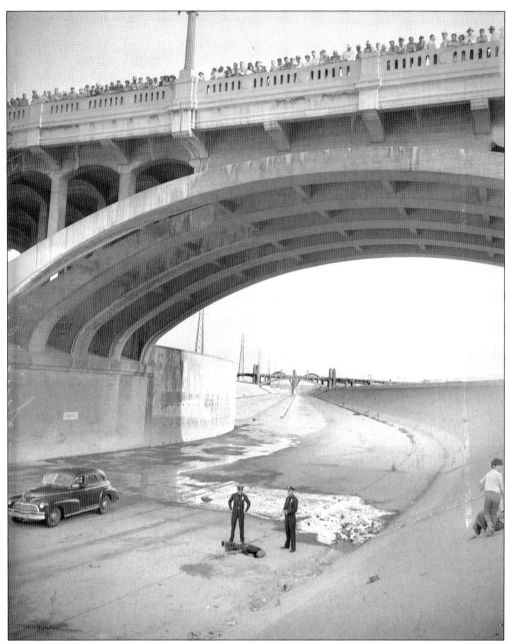

Two policemen stand over the body of a man who jumped from the First Street Bridge as a crowd of interested bystanders watches from the bridge in downtown Los Angeles *c.* 1948. East First Street connects Little Tokyo west of the river with Boyle Heights on the east side. (Courtesy of the Department of Special Collections, Charles E. Young Research Library, UCLA.)

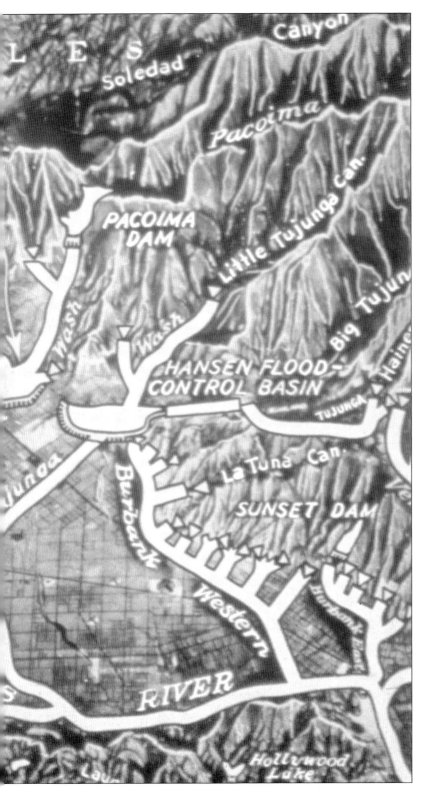

This map shows the network of channels and flood basins that would eventually control the rampages of the Los Angeles River and its tributaries. Many of the projects were already completed or were underway between the 1938 flood and the advent of World War II, when this map was compiled by the U.S. Army Corps of Engineers. (Courtesy of the Los Angeles Public Library/*Hollywood Citizen News*/*Valley Times* Collection.)

Printed on April Fool's Day, this "doctored" photograph depicts a giant ocean liner traveling down the Los Angeles River, presumably in the vicinity of Long Beach. The ocean liner was superimposed onto a photograph of the river. Newspaper editors were perhaps more fond of photograph gags in those days. (Courtesy of the Los Angeles Public Library/*Herald Examiner* Collection.)

The temporary crossing of the Anaheim-Telegraph Road was turned into a "waterfall" because of a storm in Los Angeles. Luckily, Irene Henry was saved from drowning when her car was washed off the road and into the flooded Rio Hondo. Here bystanders look at her car stuck in the river. The nomenclature of the highway has been shortened to today's Telegraph Road, which crosses the Rio Hondo where the river divides Pico Rivera and Downey on the west bank from Santa Fe Springs on the east. (Courtesy of the Los Angeles Public Library/*Herald Examiner* Collection.)

Four

BRIDGES

Perhaps the second most recognizable iconic element identified with the Los Angeles River is its bridges, many of which bear striking designs that blend the functional with the artistic. The guiding force behind at least nine of these iconic and historic bridges over the Los Angeles River is Merrill Butler, who served as the engineer of bridges from 1923 until 1961. Among these are the Ninth Street Viaduct (now known as the Olympic Boulevard Bridge), the Washington Boulevard Bridge, and the Sixth Street Viaduct, which at nearly a mile long was the longest concrete bridge in the world when it was built in 1932. Butler is also credited with bridges that span the Arroyo Seco and many other areas of central Los Angeles.

A graduate of Los Angeles Polytechnic High School, Merrill never attended college, learning civil engineering through a correspondence course. While many of these bridges no longer see the heavy traffic they once did because of the rise of freeways, they remain important links to a time when bridges were engineered to enhance and work with the landscape. Many of these bridges have been retrofitted to withstand Southern California's earthquakes, but time and neglect have taken their toll on some of the visual architectural features.

It is as true today as it was when Butler commented in an April 18, 1938, *Los Angeles Times* article that "the volume of traffic in the city appears to increase faster than outlets can be built. The result is that automobile traffic is still congested." However, back then, bridges were built with a sense of style to make that gridlock a little more pleasing.

This beautiful 1927 panorama is of the Glendale-Hyperion Viaduct, popularly known as the Hyperion Bridge, across the Los Angeles River connecting Silver Lake on the west bank with what became Atwater Village on the east side. Note the hills in the area. This bridge commemorates the U.S. victory in World War I, and its construction was overseen by Los Angeles city engineer John C. Shaw and engineer of bridges Merrill Butler. (Courtesy of the Department of Special Collections, Charles E. Young Research Library, UCLA.)

This photograph from 1886's *Shaffner's California Views* shows one of the sites used for the eventual building of the Glendale-Hyperion Viaduct. It affords some indication of what the river crossing looked like before the bridge. (Courtesy of the Department of Special Collections, Charles E. Young Research Library, UCLA.)

Hyperion Bridge, which carries Hyperion Avenue over the river, swoops down over Riverside Drive. The section shown in this photograph is near its eastern end where it intersects with Glendale Boulevard in Atwater Village. The Hyperion sewer here was declared Historic-Cultural Monument No. 164 by the City of Los Angeles in 1976. (Courtesy of the Department of Special Collections, Charles E. Young Research Library, UCLA.)

The Colorado Street Bridge is seen with the San Gabriel Mountains in the background c. 1920. The east-west Colorado Boulevard runs the length of the Eagle Rock portion of Los Angeles and Pasadena, and the high bridge built to carry it over the Arroyo Seco remains one of the arroyo's most notable landmarks. (Courtesy of the Department of Special Collections, Charles E. Young Research Library, UCLA.)

The Colorado Street Bridge is seen from the west side of the Arroyo Seco. The newspaper that this image appeared in is dated July 11, 1987. Like all of the river's tributaries, the Arroyo Seco has a history of bone-dry summers and some raging floods in the springtime when the San Gabriel peaks thaw. (Courtesy of the Department of Special Collections, Charles E. Young Research Library, UCLA.)

Construction is depicted here on the nearly completed Olympic Boulevard Bridge/Ninth Street Viaduct around 1925. This span crosses the Los Angeles River nearly a mile north of today's Vernon city line. (Courtesy of the Department of Special Collections, Charles E. Young Research Library, UCLA.)

This 1925 photograph shows workmen watching as a crane lifts materials during construction of the Olympic Boulevard Bridge/Ninth Street Viaduct in Los Angeles. (Courtesy of the Department of Special Collections, Charles E. Young Research Library, UCLA.)

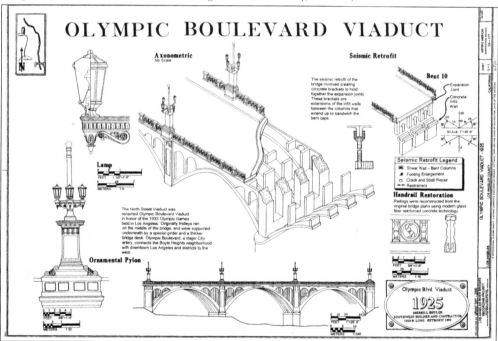

This schematic depicts the detail of the Olympic Boulevard/Nine Street Viaduct as envisioned by its builder and contractor, Merrill Butler. Butler is responsible in one way or another for the majority of Los Angeles's historic bridges. Among this bridge's most notable features are elaborate ornamental pylons and an S-shaped, acanthus leaf railing motif. (Historical Engineering American Record, National Park Service, delineated by Grant Day, 2000, courtesy of Jim Walker.)

The Los Angeles River is depicted from the middle of the river basin looking down the channel with bridges and transformers lining the view. The dramatic bridge in the center is the Sixth Street Bridge, another of the many spans attributed to the guiding force behind Los Angeles's bridges, Merrill Butler. From the riverbed, this bridge remains a popular location for commercial photographers and film shoots. (Photograph by William Reagh/courtesy of the Los Angeles Public Library.)

Built in 1932, one of Los Angeles's more spectacular bridges is the Sixth Street Viaduct over the Los Angeles River. At its western end it connects with Sixth Street, and on the east, Whittier Boulevard. The paper date is January 22, 1956. (Courtesy of the Department of Special Collections, Charles E. Young Research Library, UCLA.)

This close-up depicts the intricate design of one of the concrete pylons of the Sixth Street Viaduct on the east end of the bridge. (Courtesy of the Department of Special Collections, Charles E. Young Research Library, UCLA.)

Here the photographer took this shot looking northward on the Los Angeles River using the Seventh Street Bridge as a frame for the Sixth Street Bridge. (Courtesy of the Department of Special Collections, Charles E. Young Research Library, UCLA.)

Another of Merrill Butler's masterpieces is the Seventh Street Viaduct, which at first appears to be a double-decker bridge. In reality there is only one road, and then a bridge was built on top of an existing bridge in order to save money and provide a crossing over railroad tracks next to the river. (Historical Engineering American Record, National Park Service, delineated by Jason Currie, 2000/courtesy of Jim Walker.)

This 1955 photograph gives the detail of one of the four ornamental posts with friezes depicting the process of designing and constructing bridges found on Merrill Butler's Washington Boulevard Bridge across the Los Angeles River in the heart of the industrial district. (Courtesy of the Department of Special Collections, Charles E. Young Research Library, UCLA.)

This is a close-up view of one of the ornamental towers on the Franklin Avenue Bridge, also known as the "Shakespeare Bridge." It was built in 1926 by John A. Griffin with Merrill Butler. In 1974, it was declared a Historic-Cultural Monument by the City of Los Angeles. (Courtesy of the Department of Special Collections, Charles E. Young Research Library, UCLA.)

Pedestrians stroll across the newly completed Avenue 26 Bridge, constructed by Merrill Butler in Los Angeles in 1925. The bridge was extended in 1939. (Courtesy of the Department of Special Collections, Charles E. Young Research Library, UCLA.)

People and automobiles are seen here on the Fourth Street Bridge, another of Merrill Butler's masterpieces, during the bridge's opening ceremony in 1931. (Courtesy of the Department of Special Collections, Charles E. Young Research Library, UCLA.)

Here is a wider shot of the Washington Boulevard Bridge, seen here at its March 23, 1931, opening ceremony. East Washington Boulevard crosses the river today a short distance from the contiguous border of the cities of Los Angeles and Vernon. (Courtesy of the Department of Special Collections, Charles E. Young Research Library, UCLA.)

Five

MODERN TIMES

In the April 15, 1956, issue of the *Los Angeles Times*, Col. Arthur H. Frye Jr., army engineer for the Los Angeles District, reassured citizens living near the river upstream from Reseda Boulevard that construction in this particular section would be at an end within two months. Dust and noise from the area had led to irritation for residents. Frye added, "and local residents can further aid in maintaining the safety record by keeping their children out of the work area."

It is difficult to imagine now what a task this had been or the daily frustrations Angelinos must have encountered all along the course of the river for the span of nearly 20 years.

On November 26, 1959, the final reconfiguring of the Los Angeles River was completed; a one-mile stretch between Los Feliz Boulevard and Hyperion Avenue had been walled in. Trees were stripped away from the river's banks and massive concrete walls replaced them. Many commented that rain falling in the mountains would reach the sea far faster in the concrete channels of the river than any commuter in an automobile on L.A. roadways. In the authoritative *The Los Angeles River, Its Life, Death and Possible Rebirth*, author Blake Gumprecht writes, "By the time construction was completed, fourteen private contractors in thirty-one separate contracts with the government had moved twenty million cubic yards of earth (roughly 800,000 dump truck loads worth). They mixed 3.5 million barrels of cement, placed 147 million pounds of reinforced steel, and set 460,000 tons of stone."

It was the largest flood-control project west of the Mississippi, and it created new sets of problems, from endangered wildlife, to teens using the concrete channels as drag strips. In heavy rains today, there are always reports of people who unwittingly become trapped in storm drains or the river itself, where the water can reach speeds of 45 miles per hour.

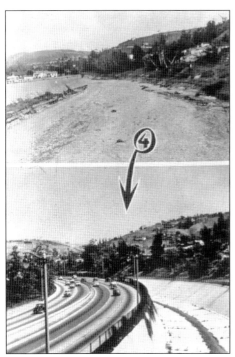

This photograph composite created by the *Los Angeles Herald-Express* depicts an area before and after the construction of the Arroyo Seco Freeway, which became known as the Pasadena Freeway or Interstate 110 between downtown Los Angeles and Pasadena. Both photographs in the composite were taken near the Pasadena Avenue Bridge. The above photograph shows what the area looked like before the freeway with the river in its natural state. Below is how it looked in 1955 after the river was reined in with concrete. (Courtesy of Los Angeles Public Library/*Herald Examiner* Collection.)

This picture from May 1954 shows a section of the railroad tracks in Long Beach as they cross the Los Angeles River. The U.S. Army Corps of Engineers eventually convinced the Pacific Electric Red Car Line to tear out this bridge. When the river swelled with water and the flotsam that comes down the channel from Los Angeles with it, the debris would cling to this bridge. (Courtesy of Jim Walker.)

This 1956 view from Elysian Park Drive shows the Los Angeles City Jail in the foreground and Los Angeles River in the background. (Courtesy of the Department of Special Collections, Charles E. Young Research Library, UCLA.)

Sepulveda Dam and a portion of the huge Sepulveda Flood Control Basin are depicted here. The dam is situated just west of Sepulveda Boulevard and extends between Magnolia and Victory Boulevards in the general vicinity of Reseda, Encino, and Van Nuys. (Courtesy of the Department of Special Collections, Charles E. Young Research Library, UCLA.)

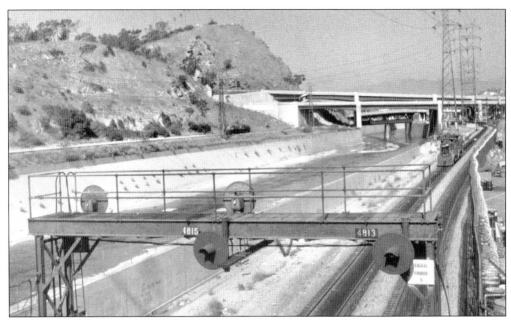

Looking northwest toward Griffith Park, this photograph was taken from the Broadway Freight Yard, located in the Midway Yard of the Southern Pacific Railroad. The location today is where the Broadway Bridge crosses the river at the southeasternmost tip of Griffith Park. (Courtesy of Jim Walker.)

This photograph shows one of the collapsed bridges that fell victim to the raging waters of the Los Angeles River. The photograph contained no other specifics. (Courtesy of Los Angeles Public Library/*Herald Examiner* Collection.)

Members of the Los Angeles County sheriff's posse search Big Tujunga Canyon for victims of weeklong flooding in 1978. The water from Big Tujunga Dam in the San Gabriel Mountains was cut off to aid the posse's efforts. About 125 searchers checked below the dam while mountain rescue teams searched above it. (Courtesy of the Department of Special Collections, Charles E. Young Research Library, UCLA.)

This bridge was built for the Los Angeles Metropolitan Transit Authority's Blue Line. The photograph looks north across the Los Angeles River at an angle. Metro replaced a one-track bridge with this two-track one in the late 1980s. (Courtesy of Jim Walker.)

This shot was taken when the bridge for Metro's Blue Line was nearly complete in 1988. The location is North Long Beach near the Virginia Country Club on the eastern bank, and the view is upstream. The Blue Line is a major carrier between the cities of Long Beach and Los Angeles. (Courtesy of Jim Walker.)

The east bank of the Los Angeles River is depicted directly in front of the Broadway Viaduct in downtown L.A. The Santa Fe Railway Bridge can be seen at the left. (Courtesy of Jim Walker.)

Taken on Christmas Day 1987, this aerial depicts the route of the Long Beach/Los Angeles light rail line to Long Beach, showing the Los Angeles River slicing through Long Beach on its way to San Pedro Bay. (Photograph by Dave Crammer/Finer Enterprises, pilot Bob Green; courtesy of Jim Walker.)

The Los Angeles River empties into the Port of Long Beach along San Pedro Bay. A couple sits on the side enjoying the view, while two boaters ply the waters. The *Queen Mary* steamship, brought to Long Beach decades ago, can be seen in the background. (Photograph by Akili-Casundria Ramsess; courtesy of Los Angeles Public Library/*Herald Examiner* Collection.)

Cargo containers are seen on the docks at the Port of Long Beach in this 1984 photograph. The Los Angeles-Long Beach waterfront is a booming import/export conglomerate unto itself. Each port is among the busiest seaports in the world. Behind the harbors, the Los Angeles River meets the Pacific at San Pedro Bay. (Courtesy of the Department of Special Collections, Charles E. Young Research Library, UCLA.)

The Santa Fe Bridge is depicted looking back toward downtown Los Angeles. A train can be seen on the Southern Pacific Railroad line on east bank of river, the bridge in the background is the Broadway Viaduct, and the tracks heading off to the left are the Union Pacific line. This photograph was taken in December 1991. (Courtesy of Jim Walker.)

This 1991 photograph also depicts the Santa Fe Bridge, looking toward the northwest. On the left is the former location of the Southern Pacific's Midway Yard. In the background is the Pasadena Freeway, also known as Interstate 110. (Courtesy of Jim Walker.)

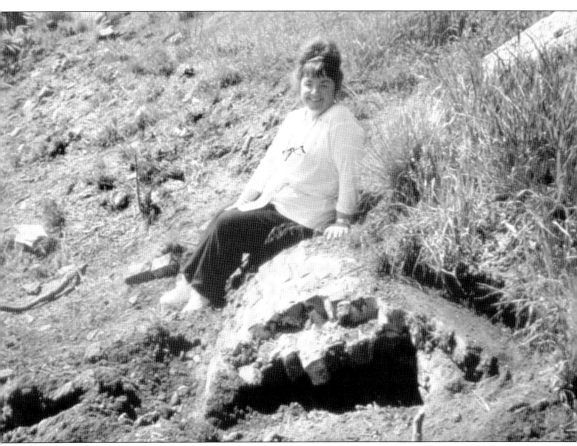

This is a portrait of Melody Carver, a nurse by night and amateur history archeologist by day. Carver and Craig Howell, a fellow amateur, unearthed the *Zanja Madre* irrigation system in February 2000. The irrigation ditch is believed to have been dug in 1781 when Los Angeles was founded as El Pueblo de la Reina de Los Angeles. The "Mother Ditch" was discovered in Chinatown. The *Zanja Madre* system ran from the Los Angeles River for more than a mile to the pueblo's plaza, where the Olvera Street marketplace is now. Residents not only got their drinking water from the ditch, but the surrounding vineyards and farmland were irrigated by its water. The site where the discovery was made is referred to by many as, simply, "the Cornfield"—a nod to the past when the parcel produced tons of corn. (Photograph by Genaro Molina; courtesy of Los Angeles Public Library/Security Pacific National Bank Collection.)

Six

HOLLYWOOD

Car chases, tense showdowns, drag strips, proving grounds for automobiles, and life and death struggles against nuclear mutated ants—the Los Angeles River has served as the backdrop for all these and more in the fantasy world of Hollywood. It is interesting to note that several of the major Hollywood studios were erected within a stone's throw of the Los Angeles River. In the aerial survey of photographs presented in chapter eight, one can still see studios like CBS Radford, Universal, Warner Brothers, and Walt Disney right next to the river's course.

It may be impossible to ever truly know an exact count or list of all the films that have used the river, especially before the concreting. But that river was used to depict tales of adventure, exploration, and romance in regions far removed from North America, usually because the river was nearby, but also because motion picture budgets precluded almost all film companies' travels to the Congo, South Seas, and other exotic locales. But clearly the river's proximity to so many studios provided the opportunity for "location" filming outside the confines of the soundstages.

After its concreting, the Los Angeles River provided the backdrop for Lee Marvin's attempt to finally collect the money due him in John Boorman's *Point Blank*. It was the drag strip for the "Greased Lightning" race from Randal Kleiser's *Grease*. Believe it or not—and thanks to special effects—Kurt Russell and Peter Fonda surfed the Los Angeles River in John Carpenter's *Escape from L.A.* And the Sepulveda Dam served as part of the Liberty Island backdrop in Carpenter's futuristic *Escape from New York*. The Los Angeles River also provides the setting for many commercials and music videos.

The Los Angeles River has had many a famous gent stare out over its landscapes; however, none perhaps looked as distinguished or as still as this stone-faced guy. This statue of Abraham Lincoln, a motion picture prop, stares out at a dry and littered Los Angeles River. It was situated among numerous discarded props on the back lot of Republic Pictures, which was located where CBS Radford Studios now stands in Studio City. (Courtesy of the Department of Special Collections, Charles E. Young Research Library, UCLA.)

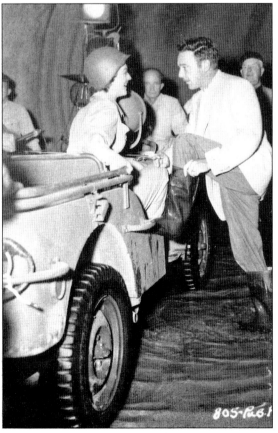

Actress Joan Weldon is seen discussing a scene for *Them!* with director Gordon Douglas, who is adjusting his galoshes. The 1954 production, which also starred James Whitmore and James Arness, concerned giant mutant ants that wreak havoc in New Mexico and head for Los Angeles. Douglas shot the film in the Los Angeles River channel, as well as the tunnel underneath the Sixth Street Viaduct where it is believed this picture was taken. (Courtesy of Steve Rubin/donated by Gordon Douglas.)

For many film aficionados, their favorite scenes shot in the Los Angeles River were for a classic crime caper that keeps its edge to this day. Lee Marvin is seen here in a still from director John Boorman's film noir *Point Blank* (1968), an influential movie on such filmmakers as Martin Scorsese, Brian De Palma, and Quentin Tarantino. The paved Los Angeles River was used by Boorman as a bleak landscape during an ambush attempt on Marvin's escaped con character, Walker. The film costarred Angie Dickinson and Carroll O'Connor. (*Point Blank* © Turner Entertainment Company, a Warner Brothers Entertainment Company, All Rights Reserved.)

One of the cinema's more prominent portrayals of the Los Angeles River—and of it being largely dry in the summertime—occurred in *Chinatown* (1974), director Roman Polanski's film noir about a 1930s private eye who gets caught up in a plot to steal water to benefit corrupt L.A. land barons. The film was nominated for 11 Academy Awards, including best picture, and Robert Towne's much-honored screenplay won an Oscar. Here Jack Nicholson as private snoop J. J. Gittes is about to get his nose cut by thugs portrayed by Roy Jenson, left, and Polanski himself, right. At one point Gittes trades small talk with a Los Angeles city morgue attendant, who allows that the nearby corpse of a drifter was taken out of the Los Angeles River. "Yeah, he drowned, too," the attendant remarks offhandedly. "Come again," Gittes says, incredulous that anyone could have drowned in that dry streambed. Faye Dunaway, John Huston, and Perry Lopez costarred in this all-time classic. (*Chinatown* © Paramount Pictures, All Rights Reserved, courtesy Paramount Pictures.)

Many scenes for both *Escape from New York* (1981), above, and *Escape from L.A.* (1996), below, were shot by director John Carpenter in the Los Angeles River. Both pictures starred Kurt Russell as the grungy, eye-patch-wearing, reluctant antihero, Snake Plissken. In the former, Manhattan is supposed to have been converted into a maximum-security prison. And in the latter, Los Angeles has been turned into a gang-infested island by an earthquake. The Los Angeles River suited Carpenter's needs because of its easy adaptability into a post-disaster-like appearance. Like a seasoned stunt person, the river has a lot of hard miles. (*Escape from New York* © Metro-Goldwyn-Mayer, All Rights Reserved, courtesy Metro-Goldwyn-Mayer; *Escape from L.A.* © Paramount Pictures, All Rights Reserved, courtesy Paramount Pictures.)

This motion picture still depicts the climactic chase between the villains in the rear helicopter and the hero in an ultra-high-tech helicopter called Blue Thunder. The sequence was shot by director John Badham for *Blue Thunder* (1983), starring Roy Scheider. The movie, which spawned a television series, was shot extensively in the Los Angeles River. The film, which costarred Warren Oates, Candy Clark, and Malcolm McDowell, concerned a crack surveillance team that operates from the high-tech whirlybird. (*Blue Thunder* © 1983 Columbia Pictures Industries, Inc., All Rights Reserved, courtesy of Columbia Pictures.)

This still represents a different angle from the same shooting sequence seen on the previous page, showing the high-tech helicopter Blue Thunder in the feature film of the same name as it begins to fly under a bridge in the Los Angeles River. Note the film crew in the bottom left-hand corner. (*Blue Thunder* © 1983 Columbia Pictures Industries, Inc., All Rights Reserved, courtesy of Columbia Pictures.)

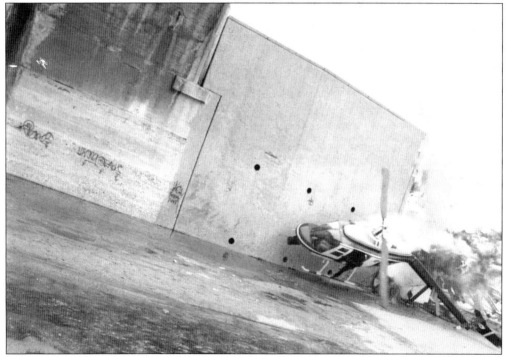

In another shot from director John Badham's *Blue Thunder*, a helicopter meets its end in one of the ancillary purposes of the Los Angeles River and its tributaries—blowing stuff up. The film and television industries' pyrotechnic teams used the river for explosions in stunt sequences. And the Jet Propulsion Laboratory (JPL) in La Canada Flintridge used the tributary Arroyo Seco for testing forerunners to space probes and other rocketry activities. (*Blue Thunder* © 1983 Columbia Pictures Industries, Inc., All Rights Reserved, courtesy of Columbia Pictures.)

Director Randal Kleiser, center, sitting atop a camera chase car and wearing sunglasses, runs through some last-minute details with his crew before shooting a sequence for the car chase scene in *Grease* (1978), starring John Travolta and Olivia Newton-John. The Los Angeles River channel nicely served the filmmaker for his motion picture adaptation of the Broadway musical. Behind Kleiser and the crew, the hot rod "Greased Lightning" can be seen. (Courtesy of Randal Kleiser.)

Before he became governor of California, Arnold Schwarzenegger's characters often ruled wherever they wanted in movies, including in the Los Angeles River. In *Terminator 2: Judgment Day* (1992), the future governor's automated and violence-prone title character fulfilled his promise of "I'll be back!" uttered in the initial hit, *Terminator* (1984). Director James Cameron created in the second film one of the most protracted, wild vehicle chases ever devised, with a tractor-trailer truck cab barreling down the paved channel of the Los Angeles River. (Courtesy of Le Studio Canal.)

The Shield is one of the many action series to film sequences for multiple episodes in the Los Angeles River. Pictured from left to right are actors Walton Goggins, Michael Chiklis, David Rees Snell, Michael Jace, and Alex O'Loughlin. *The Shield* continues a long tradition of shooting in the concrete-walled river, which was ubiquitous in many of the action-adventure series of the 1970s and 1980s, such as *Charlie's Angels, CHiPs, Adam-12, Emergency,* and *The Dukes of Hazzard.* (Copyright © FX, courtesy of FX.)

Seven

RESTORING THE RIVER

The Los Angeles River is making a comeback. Parks have been constructed around the more scenic sections of the river, offering picnic areas and walking, cycling, and jogging trails. Along with local officials and hundreds of volunteers and other organizations, the Friends of the Los Angeles River (FoLAR) works on many fronts to keep the river a viable resource. FoLAR is a nonprofit organization founded in 1986 to protect and restore the natural and historic heritage of the river.

One of the major events FoLAR has produced is *La Gran Limpieza*, the Great Los Angeles River CleanUp, the largest urban river cleanup in the country, and one of the largest multicultural, multiethnic volunteer efforts in California. A recent CleanUp saw 3,000 volunteers remove over 25 tons of trash from 15 different sites along the 52-mile length of the river, including the Sepulveda Basin and Tujunga Wash in the San Fernando Valley; Los Angeles sites in Griffith Park, Los Feliz, Silver Lake, and two in Elysian Valley; sites in the cities of Bell and Compton; and Willow Street and Golden Shores in Long Beach.

Working with the Los Angeles Conservation Corps, FoLAR volunteers regularly collect water samples from 21 locations along the entire length of the river to produce an annual State of the River report. FoLAR also created a comprehensive educational curriculum in conjunction with the Los Angeles Coalition of Essential Skills and UCLA. This curriculum is called the River School, and it works with public and private schools throughout the Southland.

FoLAR has forged alliances with the California Water Resources Control Board, the Los Angeles County Department of Public Works, the Department of Water and Power, and the Department of Recreation and Parks. It works with local and state legislators and other officials to ensure that the Los Angeles River's future will be much, much more than a large, concrete storm drain.

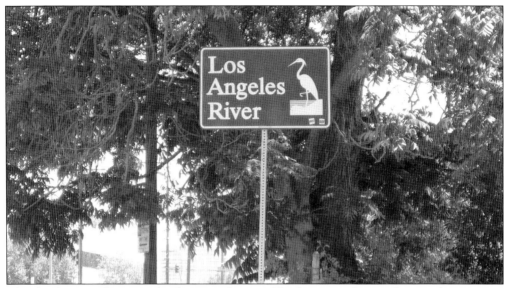

This familiar sign featuring the drawing of a great blue heron is what residents and visitors see in Los Angeles to announce that they are about to cross over a stretch of the Los Angeles River. This particular sign is on Owensmouth Avenue in Canoga Park, very near the site of the Los Angeles River's source. (Photograph by Ted Elrick.)

If Los Angeles commuters happen to glance sideways out their car windows, they will see many river scenes, such as this one of the stream's curve as it passes under Winnetka Boulevard between Vanowen and Victory Boulevards. Scenes like these have given many the mistaken impression that there really is not a Los Angeles River per se. (Photograph by Ted Elrick.)

However, if automobile commuters seek them out, there are sections of the Los Angeles River that have been restored, giving the stream an almost natural appearance, as demonstrated by this photograph taken under the Balboa Avenue overpass in the San Fernando Valley. (Photograph by Ted Elrick.)

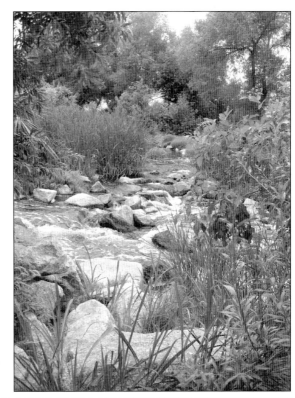

In many instances, even the minor tributaries of the Los Angeles River have been walled in with concrete, as shown in this photograph of Dayton Creek taken just after it has passed underneath the intersection of Roscoe Boulevard and Fallbrook Avenue in West Hills, California. Dayton Creek winds down to Bell Creek, which meets up with Calabasas Creek to form the Los Angeles River. (Photograph by Ted Elrick.)

This photograph, taken from Owensmouth Avenue in Canoga Park, depicts the beginning of the Los Angeles River with the confluence of Bell Creek, on the right, and Calabasas Wash, directly behind Canoga Park High School. These streams all rise in the scrubby foothills of the Santa Monica Mountains. (Photograph by Ted Elrick.)

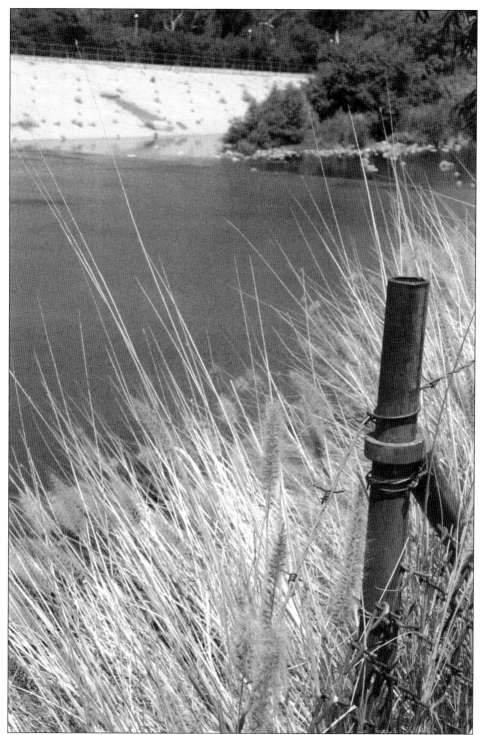

Near Los Feliz Boulevard is a section of the Los Angeles River where the soft bottomland has provided enriched soil. Trees have been planted to provide a more naturalistic riparian environment, a place for people to enjoy and wildlife to flourish. (Photograph by Jay Sheveck.)

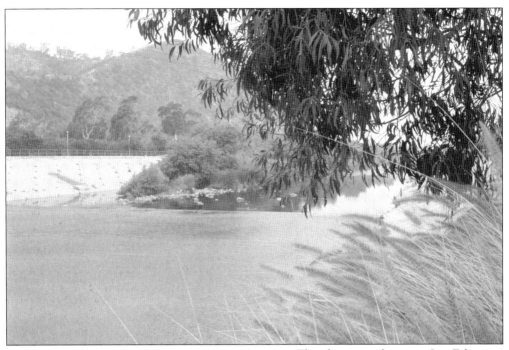

This shot was taken near Los Feliz Boulevard during the Friends of the Los Angeles River CleanUp Day on May 12, 2007. (Photograph by Helene Barbara.)

Some areas in the moist bottomlands of the Los Angeles River defy the stream's reputation as a dry valley and defy Southern California's general identification as a desert area. Here, near Los Feliz Boulevard, more lush areas almost suggest a semitropical zone. (Photograph by Jay Sheveck.)

There are portions of the Los Angeles River that would lead one to believe that this is how the river looked in its former glory, where the concrete channel is disguised by natural foliage that has been allowed to grow over and around it. One such location is in Balboa Park on Balboa Boulevard just south of Victory Boulevard in Sherman Oaks. (Photograph by Ted Elrick.)

A black-necked stilt searches for food in the waters of the Los Angeles River near the 134 Freeway's intersection with Interstate 5. Waterfowl have reclaimed portions of the river where, two decades ago, they were not found. (Photograph by Jay Sheveck.)

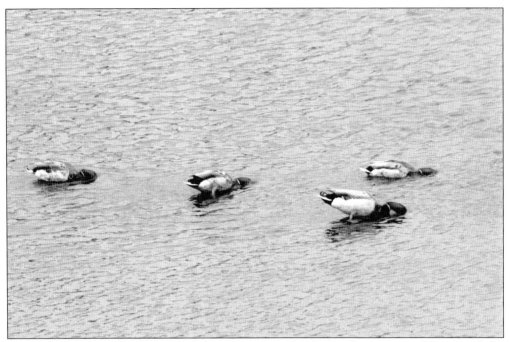

Some ducks look to the bottom of the river in search of something to eat. (Photograph by Helene Barbara.)

This is a contemporary view of the Sepulveda Dam basin. Note the land is being put to good use with a huge cornfield and a recreational center. (Photograph by Ted Elrick.)

The Los Angeles River approaches the Sepulveda Dam. The Sepulveda Basin Recreation Area in the 21st century features 2,031 acres, a wildlife refuge, an archery range, a dog park, a cricket fields, a model airplane field, and a bike path. (Photograph by Ted Elrick.)

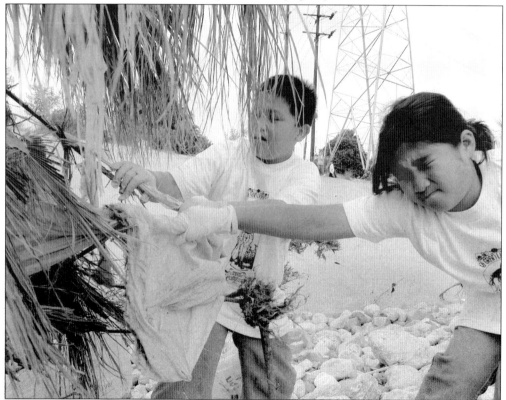

In May 2005, a friendly tug-of-war erupts between two area students during FoLAR's River School Day at the Fletcher Street Bridge in Atwater Village. (Photograph by Samantha Kuppig.)

Students give some native brush a makeover by picking accumulated litter from its branches on River School Day 2004. (Photograph by Samantha Kuppig.)

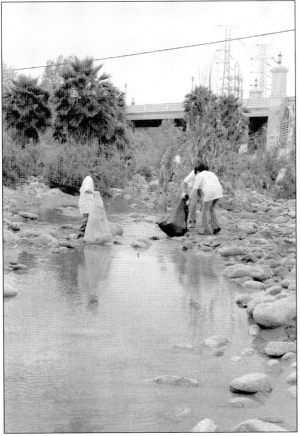

Here students fill their bags with trash from the river during River School Day 2005 near Fletcher Bridge south of Los Feliz. (Photograph by Samantha Kuppig.)

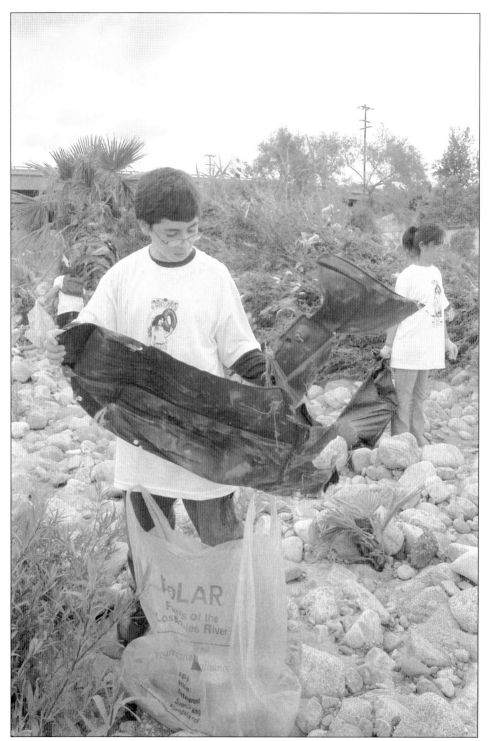

Now if this student attending River School Day 2005 can just find a couple more parts in the river, he might, like the Johnny Cash song, be able to build a complete car. Cars have been found in the Los Angeles River. (Photograph by Samantha Kuppig.)

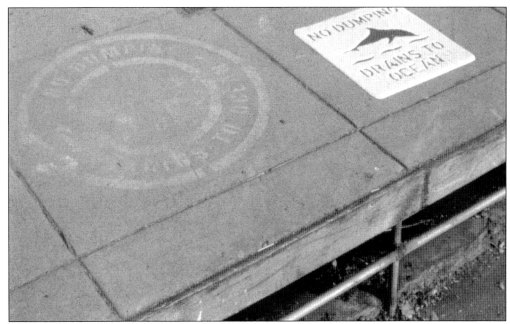

A familiar sight in Los Angeles is this warning painted near drains, alerting citizens that whatever goes in the street ends up in the Pacific Ocean. (Photograph by and courtesy of Sarah E. Starr.)

Anybody want a slightly used bicycle? Some of the discards found in the Los Angeles River include appliances, tools, vehicles, porches, playground equipment, furniture, and sheds—practically anything and everything. (Photograph by and courtesy of Sarah E. Starr.)

One can also frequently find shopping carts in the Los Angeles River. Shopping carts are popular transportation items that many homeless people use to push their belongings through the city. (Photograph by Samantha Kuppig.)

Here one of the many ubiquitous shopping carts sits next to a discarded desk. (Photograph by and courtesy of Sarah E. Starr.)

In this view from a Friends of the Los Angeles River CleanUp Day, one can see downtown Los Angeles in the distance. (Photograph by and courtesy of Sarah E. Starr.)

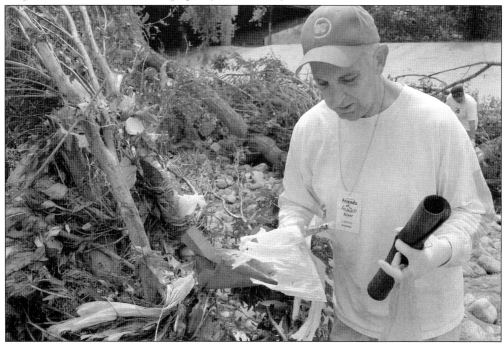

FoLAR's most vocal advocate, Lewis MacAdams, joins in during the River School Day 2005 CleanUp of the Los Angeles River. MacAdams, a well-known poet whose works include poems about the Los Angeles River, is also the author *Birth of the Cool: Beat, Bebop, and the American Avant Garde* and other books. (Photograph by Samantha Kuppig.)

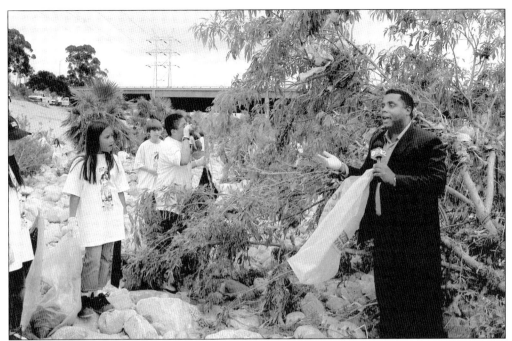

Even this Channel 2 news reporter joins in with the Friends of the Los Angeles River's CleanUp, alternating between trash and junk removal near the Fletcher Street Bridge and interviewing students. (Photograph by Samantha Kuppig.)

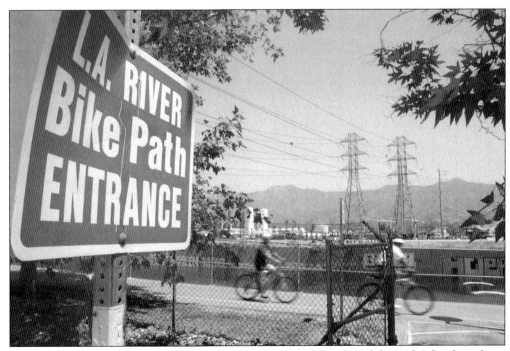

Angelinos abandon their cars temporarily to enjoy one of the many bike paths that have been constructed along the length of the Los Angeles River. (Photograph by Jay Sheveck.)

A jogger enjoys a sprint across the Los Angeles River on the Alex Baum Bicycle Bridge, designed by Paul Hobson and completed in 2002, near Los Feliz Boulevard. A project of the Los Angeles Department of Transportation, the bridge created a more effective bikeway along the river. The bridge features large bicycle wheels, like the one seen in the background of the picture. They are located at either end while bicycle-wheel motifs sit in the railing. It was named after Alex Baum, a tireless bicycle advocate who chaired the city's Bicycle Advisory Committee for more than 20 years. (Photograph by Jay Sheveck.)

When the photographer snapped this image from the south bank of the Los Angeles River near Griffith Park, a pedestrian remarked to him, "Isn't it beautiful? I often come down here to stare at the graffiti." Gang "tagging" with graffiti has been a pan–Los Angeles-area problem. (Photograph by Jay Sheveck.)

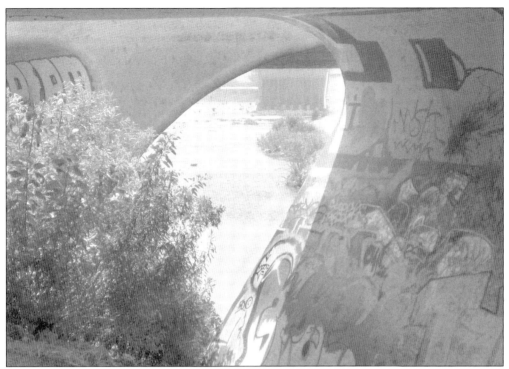

As demonstrated in the previous shot and this photograph, taken underneath Burbank Boulevard near the Sepulveda Dam, no place is unreachable for the ever-present and colorful graffiti, even when there is little chance of motorists seeing it. (Photograph by Ted Elrick.)

Here is yet another look at the seemingly, in some sections of the river, omnipresent graffiti. (Photograph by and courtesy of Sarah E. Starr.)

Graffiti surrounds this storm drain, further proving that no place is inaccessible for vandals. (Photograph by Jay Sheveck.)

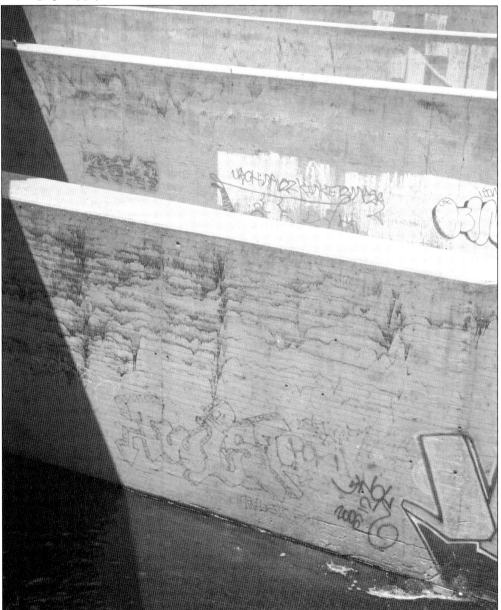

One can only wonder how difficult it must have been for the graffitists to reach this location. (Photograph by Jay Sheveck.)

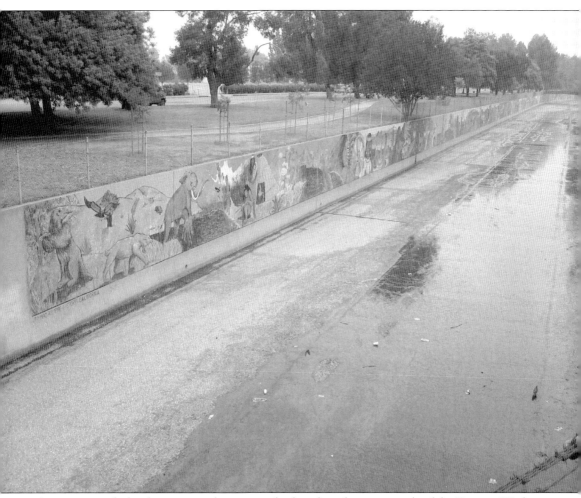

An artistic work that has remained intact can be found on the eastern side of the Tujunga Wash, which parallels Coldwater Canyon Boulevard just north of Burbank Boulevard. This nearly half-mile long mural, *The Great Wall of Los Angeles*, is the work of Judith Baca and hundreds of collaborators. The mural was painted in five sections, beginning in 1976, with the final section begun in 1983. Baca is one of the founders of the Social and Public Art Resource Center (SPARC), which is Los Angeles's leading nonprofit mural organization. The murals, depicting Los Angeles and California history since 20,000 BC, are in need of restoration, however. At publication time, only one section was marred by graffiti—the one with text describing the work. (Photograph by Ted Elrick.)

The walls of the Los Angeles River and its tributaries have been used for works of art. In this photograph, one can see three storm drain covers. Above each, note the little triangles. These were once cat faces painted by artist Leo Limon. *The Storm Cats* once gave a sense of whimsy to this area near Los Feliz Boulevard. Perhaps, like the children's song, the cats will come back, though they are probably a goner. (Photograph by Jay Sheveck.)

Looking south from underneath the intersection of the 134 Freeway and Interstate 5, this view depicts the river continuing its perpetual journey toward downtown Los Angeles and Long Beach. (Photograph by Jay Sheveck.)

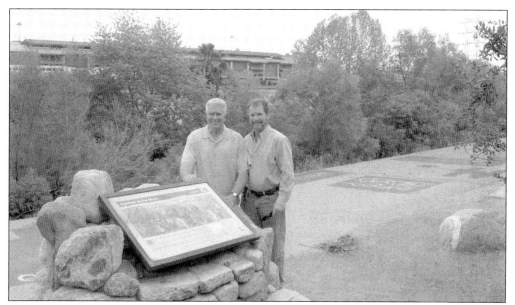

Los Angeles Public Broadcasting Station KCET's host Huell Howser, left, has shot programs on the Los Angeles River for his very popular program, *Visiting with Huell Howser*. His other popular PBS/KCET umbrella programs documenting Los Angeles history include *Road Trips*, *California's Gold*, and *California's Green*. Here with Howser is Larry Smith, executive director of North East Trees, at Steelhead Park No. 1. (Photograph by Cameron Tucker.)

This group is giving a thumbs-up for the future of the Los Angeles River during the shooting of the *Visiting with Huell Howser* program at the Golden Shore Marine Reserve at the mouth of the Los Angeles River in Long Beach. From left to right are Derrel Feiker, FoLAR executive director Shelly Backlar, Christopher Ward, Ted Masigat, Jim Ernst, Huell Howser, Maria Lopez, Gary Hildebrand, and Lenny Arkinstall. (Photograph by Cameron Tucker.)

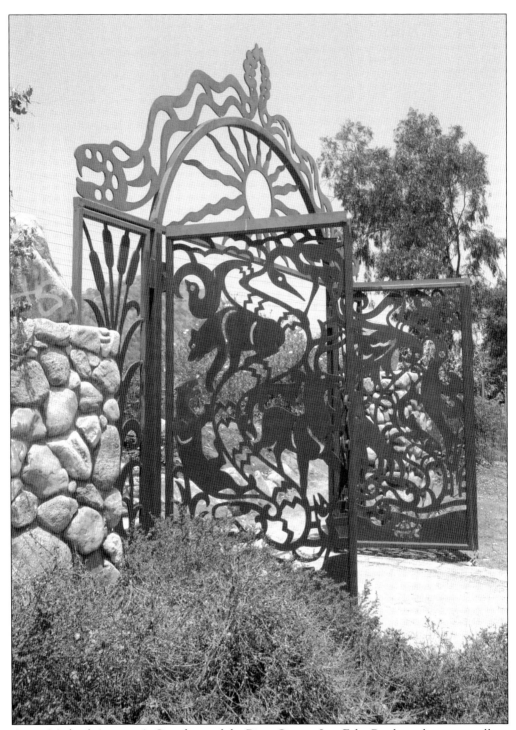

Artist Michael Amescua's *Guardians of the River Gate* at Los Feliz Boulevard is an excellent example of one of the many aesthetically pleasing and welcoming features that recently have been erected to instill a more parklike setting to revitalized sections of the Los Angeles River. (Photograph by Jay Sheveck.)

Eight

HIGH-FLYING VIEW

Periodically, the California Department of Transportation performs aerial surveys of California freeways. "CalTrans," as the agency is popularly known, is responsible for highway, bridge, and rail transportation planning, construction, and maintenance. So it isn't surprising that the survey photographs that appear in this chapter have played a crucial role in their analyses.

What follows is a series of photographs taken from a 1999 aerial survey. The pilot flew at an altitude of over 8,000 feet above ground level. This section of the survey captures a large section of the Los Angeles River from Studio City down to its mouth on San Pedro Bay in Long Beach.

Looking closely, many familiar and famous Los Angeles landmarks can be seen, as well as their relationship and proximity to the 134 Freeway, Interstate 5, and, of course, the Los Angeles River. Soft-bottom sections of the river can be seen, as well as some bridges shown close-up in earlier sections of this book.

CalTrans work can be dangerous, repairing freeways and roadways while all too often motorists in a rush to work or fed up with gridlock use every opportunity to make up for lost time, seemingly ignorant of posted speed limit signs. Everyone is indebted to CalTrans for providing this unique perspective of the river.

The tour begins in Studio City where the Los Angeles River is a thin strip of dark grey in an immense light grey concrete channel near the bottom of the picture. It curves around behind CBS Radford Studios, the large soundstage building complex near the bottom left corner. There the river joins with a flood channel from the north, which emanates from Hansen Dam Flood Control Basin very far away next to Lake View Terrace in the foothills of the San Gabriel Mountains. It crosses under the 101 Freeway and past Universal City, located in the bottom right corner. (Courtesy of the California Department of Transportation.)

As the river continues east, it completes its journey past Universal City Studios in the lower left corner. With its studio tour and Citywalk attractions, Universal is as much a theme park in the 21st century as a working studio producing films and television shows. The Toluca Lake Country Club golf course is next, just north of the studios, and then the river passes Warner Brothers Studios, also to its north, and gently curves to run parallel to the 101, also known as the Hollywood Freeway. (Courtesy of the California Department of Transportation.)

Here the river's water broadens, with the famous Forest Lawn Cemetery in Glendale to its south side. It then approaches the Walt Disney Studios on its north while it moves into Griffith Park. The parklands were donated to the city by Col. Griffith J. Griffith. Among Griffith's provisos was that an observatory be built in the park, which was done with Griffith underwriting the cost. (Courtesy of the California Department of Transportation.)

This angle of much of the same terra firma depicted in the following photograph offers a view of the river where it borders Griffith Park. Seen in the image is the Gene Autry Western Heritage Museum, with the Los Angeles Zoo on its left just north of the Harding and Wilson Municipal Golf Courses. (Courtesy of the California Department of Transportation.)

Having passed the northern part of Griffith Park, the Los Angeles River now curves south, taking its path alongside Interstate 5. Downtown Los Angeles, the city's center, is located west of the river here. The Tujunga Wash empties into the river from the east right where the big stream makes the sharp bend south. (Courtesy of the California Department of Transportation.)

The river begins to straighten here. In its center are soft-bottom sections with lush vegetation as it courses nearly directly southward. (Courtesy of the California Department of Transportation.)

The river continues toward Long Beach paralleling Interstate 5 as it leaves Griffith Park on the left. (Courtesy of the California Department of Transportation.)

Here the river crosses under Route 2, the Glendale Freeway, in the area south of Forest Lawn Memorial Park. The large body of water to the left is Silver Lake, which gives the surrounding neighborhood its name. (Courtesy of the California Department of Transportation.)

The river journeys past Elysian Park with the renowned Dodger Stadium, home of the Los Angeles Dodgers, off to the left. The Los Angeles River then crosses back under Interstate 5 and the 110 Freeway. (Courtesy of the California Department of Transportation.)

The Los Angeles River leaves Elysian Park and continues on into a more urban environment. (Courtesy of the California Department of Transportation.)

At the top of this photograph's frame, the Los Angeles River passes Union Station and crosses under the Hollywood Freeway. It passes the Sixth and Seventh Street Bridges near the bottom of the frame as it moves under the 10, also known as the Santa Monica Freeway. (Courtesy of the California Department of Transportation.)

Jumping ahead in the river's journey to the Pacific Ocean, one can see that it no longer parallels the freeways. At this point, the mouth of the river can be seen, with the riparian course entering from the bottom of the frame. (Courtesy of the California Department of Transportation.)

The Los Angeles River now flows into the Pacific Ocean at Long Beach Harbor. A marina is to its left, and the *Queen Mary* is to its right. The round building next to the *Queen Mary* once housed Howard Hughes's enormous wooden airplane, the "Spruce Goose." (Courtesy of the California Department of Transportation.)

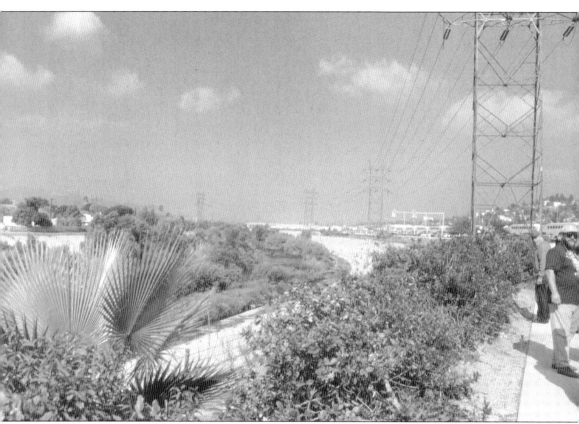

This bend in the riverbed, located by the Metrolink Shop of the Los Angeles County Metropolitan Transit Authority, shows the riot of vegetation inside the channel of the Los Angeles River. The palmettos and aquatic and other plants and animals have naturally created a riparian habitat despite the surrounding concrete jungle. (Courtesy of Jim Walker.)

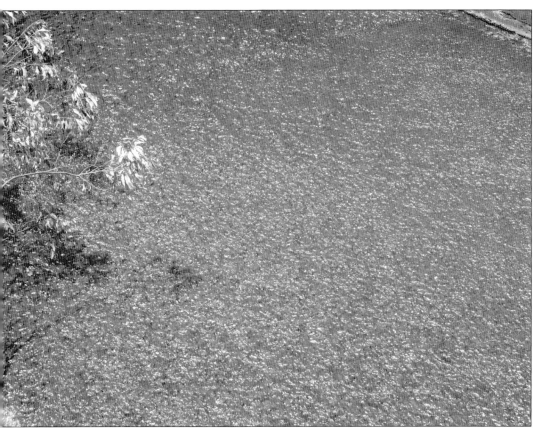

Perhaps some day, the entire length of the Los Angeles River will look this pristine. (Photograph by Jay Sheveck.)

BIBLIOGRAPHY

Gumprecht, Blake. *The Los Angeles River: Its Life, Death, and Possible Rebirth*. Baltimore, MD: Johns Hopkins University Press, 1999.

Linton, Joe. *Down by the Los Angeles River: Friends of the Los Angeles River's Official Guide*. Berkeley, CA: Wilderness Press, 2005.

Los Angels Times

Morrison, Patt, and Mark Lamonica. *Rio L.A.: Tales from the Los Angeles River*. Santa Monica, CA: Angel City Press, 2001.

New York Times

Time Magazine

www.FOLAR.org

ACROSS AMERICA, PEOPLE ARE DISCOVERING
SOMETHING WONDERFUL. *THEIR HERITAGE.*

Arcadia Publishing is the leading local history publisher in the United States. With more than 4,000 titles in print and hundreds of new titles released every year, Arcadia has extensive specialized experience chronicling the history of communities and celebrating America's hidden stories, bringing to life the people, places, and events from the past. To discover the history of other communities across the nation, please visit:

www.arcadiapublishing.com

Customized search tools allow you to find regional history books about the town where you grew up, the cities where your friends and family live, the town where your parents met, or even that retirement spot you've been dreaming about.

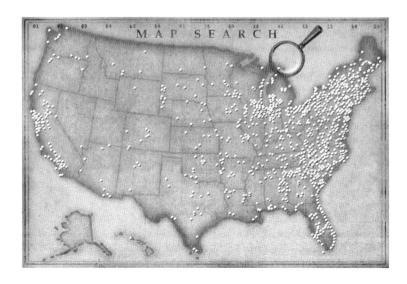